DSLR Photography for Beginners

Take 10 Times Better Pictures in 48 Hours or Less!

• Best Way to Learn Digital Photography •
Master Your DSLR Camera • & Improve
Your Digital SLR Photography Skills •

By Brian Black

Table of Contents

Digital Photography

Digital photography has become the standard today. Most cameras sold today are digital. Analog photography is on the way to disappearance except in a few niche applications. But what exactly is digital photography? In what ways is it better than analog photography? How did it earn its place of preeminence?

All photography captures an image by focusing light reflected from something in the world through a lens and recording that image in a medium. With old-fashioned analog photography, the medium was a film with light-sensitive chemicals that darkened or changed color when struck by light. The film was then processed in a darkroom using various chemicals that caused the image to appear in a "negative" – with the colors reversed – and then light was beamed through the film onto light-sensitive paper which was also exposed to chemicals to produce a "print." The process was time-consuming and included many points where mistakes were possible. It was expensive in terms of materials and labor both, but until the advent of digital photography, it was the only way that photographs could be taken, developed, and preserved.

Instead of this analog process, digital photography focuses the light from the lens onto an array of electronic light sensors hooked up to a computer processing chip to create a digital image and store it in digital memory. The stored image can be seen immediately on the camera's screen,

transmitted to other devices for storage or further processing, and digitally published on the Internet.

The advantages of digital over analog photography are enormous. There's no danger of losing photographs by accidentally exposing film, or of making a mistake in the development process that ruins the photo forever. You can see the results of your efforts immediately, and know if you need to retake a shot, as opposed to waiting hours or days before the results are available. There's no delay while the photos are processed; they can be checked at once. That means you don't have to take as many shots in order to be reasonably sure of a good one, and in addition each photo you take costs essentially nothing – no film, no development chemicals, no printing paper or slide materials. Digital photography saves both time and money by making the process more efficient and less wasteful.

You can make perfect copies of a digital photograph, whereas copies of analog photographs lose fidelity the more times copies of copies are made. Digital photographs are taken in exactly the format you will need for digital publication or for using the photos in a graphic design program. There's no guesswork involved in moving from one medium to another, no wondering how a photo that looks great in an eight by ten glossy will appear when rendered into newsprint.

What's more, with digital photography there's no need to worry about whether you're using the right kind of film. You don't need to have supplies of various speeds of film for different shooting conditions and purposes. Any type of image in any type of light can become a photo in your camera's digital memory, provided it's within the parameters your camera lens, aperture, and shutter speed can handle, one size fits all.

Finally, digital photography allows some versatile automatic controls to be implemented for things like focusing and exposure control, some of which we'll discuss in a bit.

Are there any disadvantages to digital photography? Yes, there is one potential disadvantage. Just as analog music (vinyl recording) can give you a better sound at the high end of playback than digital music, so with analog photography you can potentially achieve a finer grade of visual art than with digital photography. That's because digital photography breaks the image into discrete bits (pixels) and relies on the brain of the person viewing them to generate a whole picture out of the bits. The greater the density of the digital image, the more complete and true-seeming the image will be, but there is always a limit at any given level of refinement and technology. Analog photography, however, has no limit to how perfectly it can render an image.

Taking advantage of this inherent superiority of analog photography requires the best cameras and equipment,

though, and as digital photography continues to advance it reaches a level of refinement where the eye and brain simply can't tell the difference. Moreover, today's methods of publication are all digital, which means that even though you can (conceivably) produce a better photograph using analog methods, it won't be any better by the time it's published. For just about all practical purposes, digital photography is superior, and that's why it's rapidly becoming the way things are done for professional and casual photography alike. Today, digital photography can be produced that is extremely high in quality. This is especially possible through the use of high quality cameras and lenses, among which most of the best ones use a technique called *single-lens reflex (SLR) photography*, and that of course is what this book is about.

If your interest in photography goes beyond pointing a camera and taking snapshots of the family on vacation, hopefully this little e-book will give you some information that can help you. We'll discuss the reasons why SLR is the way to go for quality photography. We'll go over the elements of photo composition. We'll discuss aperture, shutter speed, and ISO sensitivity, and what each of these means in terms of photo quality and effects. We'll describe the different kinds of lenses you can buy for and use with your digital SLR camera. We'll go over the different common file formats for saving your pictures to memory, and a little on graphics arts programs and why it's important to learn how to use one, and the basic rules of making sure you don't lose your photos after you've taken

them. This book isn't a complete manual of the photographer's art, but it's an introduction that should give you an idea of what you're getting into.

Why SLR?

SLR stands for "single-lens reflex." The term refers to a type of viewfinder on a camera. A standard viewfinder is placed beside or above the camera lens and focuses separately from the lens. The image you see in the viewfinder is never precisely what the camera sees or what will appear in your photo, although with a well-designed viewfinder it can come very close.

A typical single-lens reflex camera

A single-lens reflex camera has no viewfinder technically so called. Instead, it uses a mirror to bend and redirect

some of the light from the lens through an eyepiece so that the photographer is looking right through the lens itself. What you see is exactly what you get. There are enormous advantages to SLR photography.

The biggest advantage is that an SLR allows you to change lenses in the camera. You can use a close-up lens, a telephoto lens, and various lenses with different aperture settings to capture just the image you want. With a viewfinder, this isn't easy to do, because the viewfinder is made to match a particular lens and will present a much more distorted image if you change the lens. With an SLR camera, because the image you see is always coming *from* the lens, it's always true *to* the lens, no matter which lens you're using.

SLR cameras are always equipped with a removable lens that can be replaced with other lenses at will. Sensors are normally built into the viewing display in an SLR camera, too. They tell you whether there's enough light at the present aperture setting and shutter speed, and how well the image is focused. Focusing is much easier with an SLR than with a viewfinder, as you can see the image as it's presented by the camera lens and see whether it's in focus or not.

All of these are reasons why single-lens reflex cameras have become the standard for serious photography. That was true long before digital photography became practical (the first SLR cameras were analog). But today, many of the famous names in manufacturers of analog SLR cameras have come out with excellent digital SLR cameras, too. These include Nikon, Canon, Pentax, and others. The advantage of craftsmanship in a digital camera doesn't go to the "digital" part (the electronic sensor array and storage routines), but to the part of the camera that remains analog, with the lens being the single most important feature.

A single-lens reflex camera of top quality costs more than most other digital cameras. (That was also true about analog cameras; the SLR cameras were usually more expensive than the viewfinder versions.) You can expect to

pay $400 - $1,000 for a decent DSLR camera, with the priciest, such as Nikon's D3X, running as high as $8,000. Specialized lenses cost money, too. A DSLR is not really needed for casual snapshots. But if you want to take your photography to a higher, more serious level, it's definitely the way to go. In that case, you should expect to spend some money, unfortunately. Digital photography has shaved some of the cost from the art, but quality is still fairly expensive.

Recommended DSLR Cameras

If you want to take advantage of the possibilities inherent in digital SLR photography, you're going to have to spend a bit of money on a good camera and accessories. However, there's still a pretty wide range of prices. As long as you go with a well-respected manufacturer, you can expect quality. That said, the biggest and best camera makers are Canon and Nikon, so if you're going to buy a DSLR camera, it's highly recommended that you get one made by either of the two.

Aperture: What Is It?

Aperture refers to the width of the shutter opening in a camera when a picture is taken. A wider aperture lets more light in and allows pictures to be taken in dimmer light. However, it also creates shallower depth of focus, so that parts of the picture that are more distant (or closer) than the center of focus will appear out of focus. Depending on what effect you're looking for, this may or may not be a good thing.

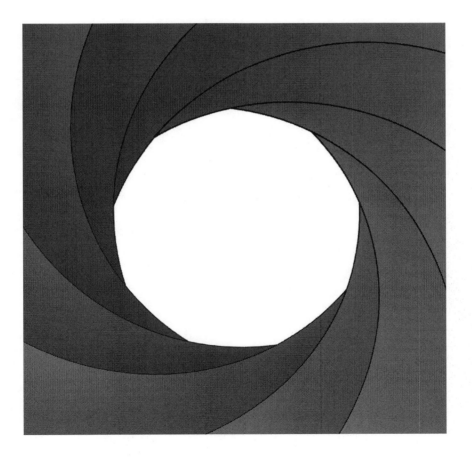

The aperture of any camera (not just digital cameras) is measured in terms of "f stop" or "f number." The technical meaning here involves a 2-based logarithmic scale so that 1 f number difference doubles or halves the amount of light entering the camera. There's a mathematical formula for this which we won't go into, as it's not terribly important for purposes of taking good pictures. (It's related to the area of a circle.) The lower the f number, the larger the aperture will be. F 1 is a very wide aperture, while F 8 is very narrow. A lens comes equipped with a range of apertures which is controlled by device called a diaphragm that functions much like the iris of your eye. Note that this is not a feature of the changeable part of the lens. The diaphragm is part of the camera mechanism behind the lens not of the lens itself. Each lens is sold with a description or rating that specifies the maximum and minimum aperture. This rating is sometimes called the lens *speed*, as it affects how fast the shutter speed needs to be with that particular lens. Shutter speed and aperture are inversely related, so that a wide aperture requires a faster shutter speed under any given light conditions. The wide aperture lets in more light, and a faster shutter speed lets in less by reducing the time that the sensors are exposed.

There's also a consideration when it comes to framing the picture and seeing it through the viewer. A narrow aperture, while it may be appropriate for taking pictures in bright light conditions, isn't so good for viewing the picture before you take it, because it reduces the light going through the lens to your eye. For that reason, SLR cameras

are normally equipped with what's called "automatic aperture control." This sets the aperture to the widest possible for the lens while viewing the scene and metering the light, and closes the aperture down to the appropriate level when the shot is taken.

A digital SLR camera can be set to adjust part of its settings automatically in various ways. One type of semi-automatic adjustment is called "aperture priority." In this type of photography, the photographer manually chooses the aperture and allows the camera to automatically set the shutter speed and ISO sensitivity for the correct exposure. Using this technique allows the photographer to control the type of focus effect desired without having to manually set all three variables. A different look to a photograph is achieved with a high depth of field compared to a shallow depth of field. Note the difference in the two photos below.

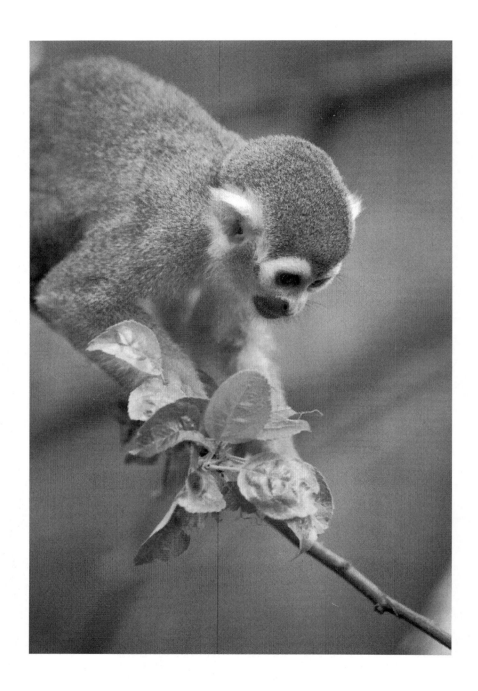

In this picture, the depth of field is shallow, so that only the squirrel monkey and the branch it's sitting on are in focus.

This picture was taken using a wide aperture. It used a relatively fast shutter speed to cut down on the light and correctly expose the photo.

In this picture, on the other hand, the depth of field is extensive, so that the whole landscape appears in focus. This photo was taken with a narrow aperture, and the shutter speed was relatively slow in order to let enough light in for proper exposure. If anything had been moving

quickly through the photo it might have appeared blurry as a result, not because of depth of field but because of the object moving across the field of view while the picture was being taken. (We'll discuss effects of shutter speeds below.)

Which effect is better? It depends on what you are trying to portray. A photo in which only the immediate center of focus is clear draws attention to that subject. This might be appropriate for a portrait or for a close-up of one particular item. It would not be appropriate for a panoramic shot in which the entire scene needs to be in clear view.

By using aperture priority, you can take pictures of the appropriate effects and, within the limitations of the lens you are using, adjust the shutter speed and ISO sensitivity to allow more or less light in according to the f-stop you have selected, f-stop being a measure of aperture, with the larger numbers indicating a smaller aperture. The f-stop is what you select on your camera to set the aperture. (It's important to remember that a slow shutter speed makes your photography more sensitive to camera motion, though. A very slow shutter speed requires a steady hand or in some cases a tripod to keep your camera motionless. Otherwise the entire picture will be blurry and streaked.)

Sometimes a lens has its best performance when it is not fully opened, i.e. using a tighter aperture than the maximum allowable with that lens. For this reason, it's best to have a lens appropriate to the type of photography intended, that gives good results with the aperture opening

you want to use. Also, there are types of photography in which a high depth of field is desirable even though the subject is very small, for example macro photography. Special lenses are appropriate for this as well. We'll get into lens types in more detail below.

Shutter Speed: What Difference Does it Make?

As noted above, there's an inverse relationship between aperture and shutter speed. A fast shutter speed does not let in as much light as a slow shutter speed. If you're using a tight aperture to achieve high depth of field, you will need to use a slower shutter speed (for any given light conditions) than you would while using a wide aperture. Shutter speed is also sometimes called exposure time. It is measured in terms of the amount of time that the camera shutter remains open while taking the picture. A fast shutter speed means a short exposure time, while a slow shutter speed means a long exposure time. (In fact, there is such a thing as "timed exposure" in which the shutter remains open for several seconds in order to photograph something in very poor light or to achieve special effects. This kind of photography is always done using a tripod to stabilize the camera.)

Also as noted above, a slow shutter speed creates greater effect from camera motion so that a tripod may be required for stability at very slow speeds. However, what matters here is the *relative* motion of camera and subject. Taking a picture of a moving object with a slow shutter speed can create a blurred image of the object (and the suggestion of motion). Using a faster shutter speed makes the object appear more crisply, with better definition and less blurring. Which of these is desired depends on what effect one wants to create in the image.

Shutter speed is measured in fractions of a second, with standard shutter speeds ranging from 1/1000 of a second to

one full second. The shutter, like the diaphragm that controls aperture, is part of the camera body and mechanism, not part of the lens, but in addition shutter speed is set independently of what lens you are using (which is not true of aperture).

The shutter speed and the aperture are inversely related. To properly expose a photo, it's necessary to have a slower shutter speed the narrower the aperture is set and vice-versa, given any specific combination of lighting conditions and lens speed. Just as it's possible to have a camera automatically set the shutter speed while maintaining a constant aperture (aperture priority), it's also possible to maintain a constant shutter speed for a particular effect and vary the aperture automatically instead (shutter speed priority). You could have a very fast shutter speed to capture fast-moving objects with crisp focus, or a slower shutter speed to show the motion of the objects with artful streaks. Your camera would then adjust the aperture to let in more or less light as needed to take a properly-exposed picture given that shutter speed and ambient lighting.

Fast train with motion blur, taken with a slow shutter speed.

Similar train, no motion blur – taken with a fast shutter speed.

ISO Sensitivity

The third factor besides shutter speed and aperture that determines the exposure of a picture is the light sensitivity of the electronic array that takes in the light and forms the picture. This is adjustable in most digital cameras and is usually called "ISO sensitivity."

The term "ISO" is taken from an international standard measurement of film speed. While the measurement doesn't directly apply to digital photography it has been borrowed to do so, and the sensitivity to light is displayed as ISO 200, 400, and so on. The higher the ISO sensitivity, the less light will be required to produce a given exposure. With greater light sensitivity, your camera can produce a given desired picture quality at a faster shutter speed and/or a narrower aperture. This is useful when you are taking pictures in dim lighting and don't want either the blurred motion effect of a slow shutter speed or the narrow depth of field that results from a wide aperture.

ISO was originally a measure of film speed, as in this roll of ISO 400 color film.

One might wonder in that case why light sensitivity wouldn't simply be set always to the maximum, except when you want to produce one of those two effects (narrow depth of field or motion streaking). The answer is that with digital photography just as with analog photography, very high light sensitivity produces something called "noise." This is the introduction of random marring that wasn't in the picture as seen by the eye. The effect, whether using a very fast film or a very fast ISO sensitivity digital setting, is a grainy quality to the photo that is generally undesirable.

For that reason, there's a trade-off between ISO sensitivity and the other factors that impact exposure (shutter speed and aperture) and it's best to set the ISO sensitivity to as low a level as is practical given the prevailing light conditions. If the picture can be taken at a lower ISO sensitivity and still use a shutter speed fast enough and an aperture narrow enough to achieve the effect you want, it should be. At the same time, though, some photos do benefit from a higher ISO sensitivity. A photo that would normally require a flash can be taken without one using higher ISO sensitivity, avoiding the distorting effects of flash light. Also, a photo to be taken in dim light might be best taken with high ISO sensitivity rather than a slow shutter speed or a wide aperture. It all depends on what you're looking for in the final picture.

Night photo taken with no flash using ISO 1600 setting (very fast).

All of these considerations are based around the idea of optimum exposure for the picture – the exposure that will render a photo that captures all elements in the scene well. It's also possible to deliberately vary the exposure so as to either underexpose or overexpose the picture (in terms of the theoretical "optimum") for a particular effect or emphasis. We'll go into that more in a later section. For now, the important thing is to understand how aperture, shutter speed, and ISO sensitivity interact to set the exposure of the photo, and what the effects are of varying each of these three elements.

Specialized Lenses

The biggest advantage of a single-lens reflex camera over other types of camera is the facility with which the photographer can change the lens. Typical non-SLR digital cameras come with a single lens with moderate zoom capability. The lens is non-detachable, which has one minor benefit: the seal prevents dust or moisture from getting into the camera body. However, a well-designed lens fastening in an SLR camera reduces any contamination to a minimum so that this is not a serious concern.

The lens in a digital SLR camera is detachable. It can be removed from the camera and replaced by a different lens producing a different effect. Replacing the lens also changes the view in the viewfinder, because the light going to the viewfinder comes through the lens just as does the light used to take a picture.

There are many different kinds of specialized camera lenses. The following are the most common kinds used and the ones that you as a photographer will most likely want to become familiar with: telephoto lens, wide-angle lens, zoom lens, normal lens, macro lens (also called close-up lens), and fish-eye lens.

Before going into each type of lens, let's spend some time discussing factors that are common to digital SLR photography and that set it apart from analog photography.

Today's camera lenses are specifically designed with digital SLR photography in mind. As long as you're buying lenses new, you should not run into any serious problems. However, it's also possible to find used lenses on the resale market. Older lenses may fit your camera in the sense of it being possible to attach the lens to your camera body, but may cause some unwanted effects. These include internal reflections that can cause ghost images to appear in your photos.

To begin with, digital SLR cameras have sensors that are slightly smaller than the area of a 35mm frame of film, which is the film size that was normally used with analog SLR cameras. This fact changes the effective focal length of every lens used with the camera.

Secondly, it's important to consult your camera's manual in regard to what lenses are fully compatible with the camera. Since lens mountings are fairly standard, especially within a particular camera brand name, it's quite possible to find lenses that can be physically mounted on your camera but that may cause problems for you in use. In particular, check whether the lens you are using is designed for a specific type of sensor, such as an APS-C sensor. It is actually possible to cause damage to your camera by using a lens that isn't fully compatible.

The third thing to consider is what type of photography you want to do. A fast lens (one with a high maximum aperture) has advantages for indoor photography or portrait photography. On the other hand, a slower lens (one with a lower maximum aperture) is usually less expensive and may be perfect if you mainly want to focus on outdoor photography and on pictures featuring broad depth of field.

The main thing to keep in mind is that a lens is a significant investment and it's best to do your research before committing yourself to owning one. Know your camera, know the lens you intend to buy, and know what kind of

photography you want to practice, and using those as a guide you can't go too far wrong.

About Focal Length

One of the key variables in a lens is its "focal length." In fact, variation in focal length determines the category into which most lenses fall: normal, wide angle, telephoto, zoom. Focal length is defined as the distance between the center plane of the lens – which means a line drawn sideways through the lens right in the middle of its thickness – and the camera's light sensor.

Your eyes also have a focal length, being the distance from the center plane of the eye's lens to the retina, and that focal length is about 22 mm. But the effective focal length depends on the sensor size (a larger sensor size means a shorter effective focal length), and the camera has a larger light sensor than your retina. Also, not all cameras have the same sensor sizes, and this can impact effective focal length, too. In practice, and for most digital SLR cameras, a "normal" focal length is considered to be between 35 mm and 85 mm. This gives a picture that's pretty close to what the eye sees (although there's no such thing as a perfect match).

What does focal length do? Two primary things. First, it varies the magnification of the image. A longer focal length gives greater magnification, so that a long focal length (85 mm or greater) is considered a telephoto lens: it works like a telescope. A shorter focal length may make things seem

smaller in the image than they do to the naked eye, while capturing a broader area (just as if you're farther away from a scene, you can see more of it, but what you see seems smaller). Short focal length lenses (generally shorter than 35 mm) are called wide-angle lenses. (Remember, though, that the size of the camera's sensor makes a difference here).

The second thing that focal length does is to increase or reduce depth of field. Generally speaking, the shorter the focal length, the greater the depth of field. (As discussed elsewhere in this book, though, depth of field also varies inversely with aperture).

Lenses may be of one fixed focal length (prime lenses) or they can be made to vary the focal length. A lens with a variable focal length is called a zoom lens. Zoom lenses may be telephoto zoom lenses (with their focal lengths all in the normal to telephoto range), wide angle zoom lenses (with focal lengths in the wide angle to normal range), or "superzoom" lenses (whose range runs all the way from wide angle to telephoto). A zoom lens is convenient for shooting different types of pictures in the field, as it replaces a larger number of fixed-focal-length lenses. Many photographers see a loss of picture quality with even the best zoom lenses compared to fixed-focal-length lenses, however.

When buying lenses, there's always a trade-off to consider between convenience and picture quality. The highest potential picture quality is achieved using prime lenses

(those of fixed focal length), but that's pretty inconvenient in the field, because it means you have to lug about many different lenses for different purposes and spend time changing them, possibly losing an opportunity for a great picture. A superzoom lens maximizes convenience, because it's a single lens that's good for almost any shot (except something specialized like macro photography or fish-eye pictures), but minimizes the potential picture quality. I don't mean to say that zoom lenses give you trashy pictures, though; a well-made zoom lens delivers high quality pictures, just not the best possible. As a general rule, the wider the range of focal lengths a lens provides, the more of a compromise it represents in terms of potential picture quality. (At the same time, of course, the wider the focal length range, the greater the convenience.)

Telephoto Lens

A telephoto lens is one that magnifies the image seen. Telephoto lenses have magnification measured as a multiplier. For example, 5X magnification means that any objects seen appear five times their normal size. A telephoto lens is used for shooting subjects that are far away when the photographer either can't get close to the subject or would prefer not to. This type of lens is often used for sports photography and wildlife photography.

Another use for a telephoto lens arises from the fact that magnification, combined with a wide aperture, creates very narrow depth of field. This can be useful in portrait photography when the desired effect is a crisply defined portrait against an out-of-focus background.

Using a narrow aperture with a telephoto lens, however, creates a different effect. Depth of field is great as is always the case with a narrow aperture, but the magnification creates a type of distortion in which the objects in the picture appear to be closer together (in terms of distance from the photographer) than they actually are. Space becomes visually compressed in the picture.

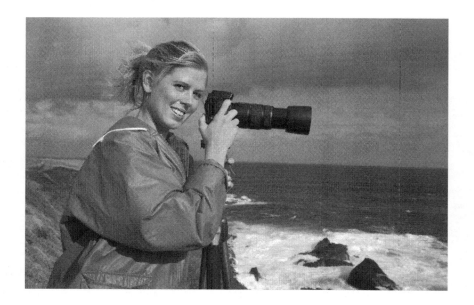

Some other effects arise with magnification. Small motions of the camera become magnified just as the images of the things viewed are magnified. Telephoto photography can sometimes require use of a tripod or other stabilizing device for this reason even when the shutter speed would normally be fast enough to avoid that necessity. The same is true for motions of the objects in view, which can be a bit

hard to track for this reason. Many telephoto lenses also have a fairly narrow maximum aperture, which can require use of slower shutter speeds than would be optimum for the light conditions.

Things to Know Before Buying

Telephoto lenses come in a wide variety of amplification ranges, so it's hard to recommend equipment without qualification. Also, it's important to buy a telephoto lens that's designed for your camera instead of a different one.

A note about the focal lengths of telephoto versus normal versus wide angle lenses: there's no standard that is universally accepted or "official," so any focal length ranges are ballpark. Generally speaking, though, a normal lens is considered to be about 35 to 85 mm in focal length. A telephoto lens is 85 mm or longer, while a wide-angle lens is under 35 mm. But you will find some lenses that are called "telephoto" or "wide-angle" which are outside those ranges. It's not an exact science, unfortunately, and you need to pay some attention to what effect you want in a lens and not get distracted by advertising.

A wide-angle lens is in some ways the opposite of a telephoto lens. It's a lens with a short focal length (generally 35 millimeters and under) that captures and keeps in focus a wide view, while a telephoto lens is one that focuses on a narrow view in the distance. The magnification with a wide-angle lens is often somewhat negative, i.e. objects appear smaller or more distant in the photo than they are in reality.

Photo taken with wide-angle lens

A wide-angle lens is used for panoramic shots, pictures of buildings and architecture, and other pictures when you want to include a wide area in the photo rather than focus in on a single object.

Lens Multiplication Factor

The standards for focal length were developed originally with reference to cameras using 35mm film. Digital cameras frequently have a slightly reduced sensor plane size that gives the camera a "lens multiplication factor" that effectively increases the focal length of the lens. The lens multiplication factor can range from 1.0 (no distortion) to 1.6, depending on the camera. Your documentation for

your digital SLR camera will include the lens multiplication factor and you should check it to adjust your expectations accordingly. This is most significant when using a wide-angle lens.

As noted earlier, though, most new lenses are built with this fact of digital cameras in mind, so that a lens that meets the specifications of your camera will not require any such modification of what you can expect from it. Still, it's a good idea to bear it in mind, particularly if you switch from one DSLR camera to another.

Things to Know Before Buying
Wide angle lenses really run the gamut when it comes to pricing. As always, make sure the lens you choose fits your camera, and also pay attention to the specifications. Not all wide angle lenses (or telephoto or zoom lenses) are identical, and you want one that gives you the focal length and magnification you're looking for.

Zoom Lens

A zoom lens is an adjustable telephoto or wide angle lens, essentially. (Or sometimes both.) Unlike a prime lens, a zoom lens has a variable focal length. It can be adjusted in one or both directions, to function as a wide angle, normal, or telephoto lens. It can be extremely convenient if the photographer is taking many different types of pictures as it results in having to carry around fewer lenses. On the other hand, a zoom lens tends to be bigger and heavier than any of the lens types it replaces, as it includes glass lens elements for different purposes, adding to the size and weight.

Another drawback to using a zoom lens is that setting the aperture can be less precise. A given f-stop may not produce the same effect at one magnification that it does at another. This is one of the reasons why a prime lens gives potentially higher-quality photos than a zoom lens, despite the relative inconvenience.

The telephoto effect or zoom effect can be achieved in two other ways than by use of a specialized lens. The other two ways involve manipulation of the digital image itself and so are only available with digital photography. One of these is called "digital zoom." It is created by increasing the size of the central portion of the picture and adding extra pixels to it. The result is lower in quality than what can be achieved by an optical zoom (zoom lens).

The other digital way of achieving a zoom effect is called a cropping zoom. This also uses the central portion of the

image but does not add extra pixels, simply cropping the image and blowing it up.

The highest-quality zoom pictures, however, can be taken with an actual zoom lens or use of optical zoom.

Wide-Angle Zoom Lens

A wide-angle zoom lens is a wide-angle to normal lens that allows variable settings – essentially a zoom lens whose range covers the wider focus possibilities. Some wide-angle zooms are strictly wide angle lenses offering variable focal lengths, while others extend their ranges into the normal lens parameters. Focal length of such lenses ranges from 12 mm up, into the normal lens ranges, depending on the specific lens model. Some wide-angle zoom lenses exhibit a bit of barrel distortion at their more extreme settings; this refers to an image that looks "barreled out" or "ballooned out" at the edges, a kind of mild fish-eye effect. Usually such lenses come with a lens hood which helps prevent unwanted light entering the frame, causing loss of contrast.

Things to Know Before Buying

Wide angle zoom lenses see somewhat less use than telephoto zoom lenses (which is what most people mean when they say "zoom lens") and there aren't as many to choose from on the market, but you can still find wide angle zoom lenses for various budgets.

Telephoto Zoom Lens

This is what most people think of when they think of a zoom lens. It's an adjustable telephoto lens that keeps the action in close view. The usual maximum focal range is between 85mm and 400mm. Telephoto zoom lenses sometimes extend their range into the normal lens territory - below 85mm - but not always.

These are not inexpensive lenses, especially the relatively fast ones that allow wide apertures. They're good for action photography where you need to maintain fast shutter speed to avoid blurring and want to take closer pictures of distant moving objects.

Things to Know Before Buying

Although telephoto zoom lenses tend to be pretty pricy at the high end, you can often find bargains if you look for them. The quality varies widely, however, and in all cases the lens is the most crucial part of the camera for producing good images. As always, make sure the lens you choose is appropriate for your camera, and pay attention to the range of focal lengths as well.

Superzoom Lens

These lenses are popular to keep on your camera, because they have a very wide range of focal lengths, all the way from wide-angle to telephoto. A good superzoom lens will usually have a focal length range from 28mm to 300mm. This chops off the extremes possible with wide-angle or telephoto zoom lenses, but covers a great variety of possible shots.

Many specific types of photography can achieve better results with a more tailored lens rather than a superzoom lens. However, a superzoom lens is ideal for travel photography, where one is somewhat limited to how many lenses can be easily carried about, and where opportunities

need to be seized quickly. Since the superzoom lens covers most of the photographs you will probably want to take in most situations you are likely to face, it's not a bad choice as a "default" lens for your digital SLR camera.

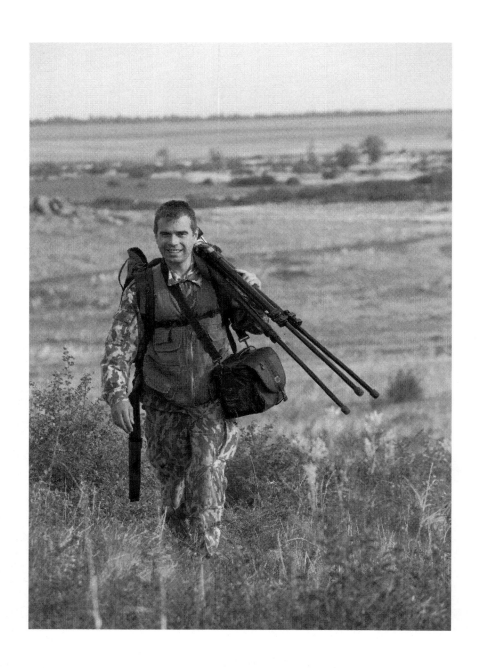

Things to Know Before Buying

There's not much to say about superzoom lenses beyond what's said above and the usual advice regarding buying lenses for your camera. Make sure the lens is designed to fit your camera, pay attention to the range of focal lengths and have an idea of what you're looking for in that regard, and also observe the f-stop rating which will tell you how fast the lens is.

Normal Lens

A normal lens is one whose focal length gives a picture similar to what the eye sees, neither magnified like a telephoto lens nor with an expanded view like a wide-angle lens. It's usually a prime lens, meaning it has a fixed focal length that can't be changed. These lenses are often made with a wider aperture than other lenses so that they can be used in dimmer light than those with a narrower aperture, at a given shutter speed. Of course, that means the image will have a narrow depth of field. The main use of the prime lens is for portrait photography where that is exactly the effect desired.

Things to Know Before Buying

Normal lenses, like most lenses, have a wide price range. In the case of normal lenses, the focal length is fixed so you're not looking at a range. The focal length of a normal lens ranges from 35mm to 85mm, so it's important to know what you want here, as different focal lengths give different results in terms of depth of field (although all normal lenses have a fairly shallow depth of field). The longer the focal length of the lens (all else being equal), the narrower the depth of field. Thus, a normal lens with a 40mm focal length has a wider depth of field than one with an 80mm focal length. Pay attention to the F-stop maximum and minimum and any additional features the lens provides.

Macro (or Close-Up) Lens

A macro lens, also known as a close-up lens, is one that allows a much closer focus to a small subject. Macro photography is typically used to capture close views of very small things such as flowers and insects. The lens does not have to be extremely close to the subject to take the picture, allowing close-ups to be taken of subjects that might otherwise be scared away, e.g. a bug that thinks of the photographer as something that might want to eat it. Macro lenses are rated according to their magnification factors, technically called "reproduction ratio." A macro lens should have a reproduction ratio of 1:1 or greater, meaning that the image on the sensor is the same size as the object being photographed or greater. Thus, photographing an inch-long grasshopper should produce

an image that is 1 inch long or longer, taking up a substantial portion of the sensor area.

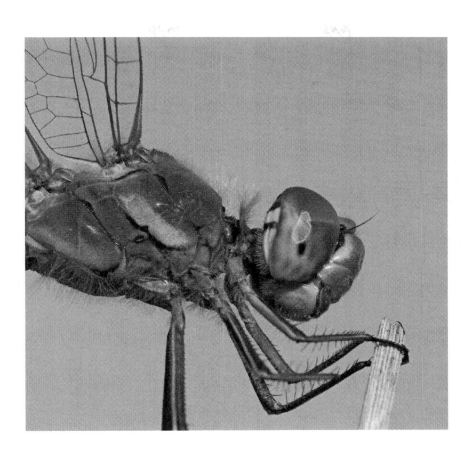

A macro lens is most often used in nature photography, but it also comes in very handy for portraiture. A macro lens is usually wide in its maximum aperture, a feature permitting shallow depth of field. They are also usually very high in optical quality. This is a specific function lens, rather than a general purpose lens.

What's the difference between a macro lens and a telephoto lens? Both of these magnify the subject and have a longer than normal focal length. The difference lies in how the lens focuses. A macro lens allows a very tight, sharp focus on a single object, producing a specific effect, like having the object under a magnifying glass, where every detail shows up crisply in the picture. The low depth of field in macro photography means that the rest of the picture is out of focus but the object of focus is very, very sharp. A telephoto lens, in contrast, takes a picture that looks like a "normal" picture, but at a greater distance than can be done with a normal lens.

Things to Know Before Buying

If you do a lot of close-up photography you may need more than one macro lens, with different degrees of magnification. All macro lenses give you low depth of field and sharp focus on a single object in view, but the specifications do vary and it's important to know what they are before deciding to buy.

A fish-eye lens is an extreme wide-angle lens that deliberately adds a spatial distortion to the picture. An image taken with a fish-eye lens can appear with the central portion (where the camera is focused) enlarged while the peripheral portions of the picture are reduced in size and clarity the further they are from the center. Unlike

a picture taken with a standard wide-angle lens, the distortion with a fish-eye lens is deliberate.

The angle of view with a fish-eye lens is usually 180 degrees (that is, a full semicircle) but fish-eye lenses can be found to take as much as 220 degrees of view. This is specialized photography intended to produce a particular distorted, artistic effect.

A variation on the fish-eye lens is the "circular" fish-eye, which rather than filling the entire frame with the fish-eye effect, creates a circular image within the frame that is distorted in this way while the rest of the picture is flat.

Fish-eye lenses are most commonly used in landscape photography. However, they can be fun things to play with in other types of photography as well, for example allowing a portrait that resembles an M.C. Escher drawing.

Things to Know Before Buying

You can get good fish-eye lenses for quite reasonable prices. One thing to bear in mind is whether you want a circular or a full-frame fisheye lens, as these give different effects. A circular fisheye lens shoots a wide-angle distorted picture in a circle that's part of the field of view, while a full-frame fisheye lens turns the entire field of view into a fisheye effect.

Canon and Nikon generally have the best fisheye lenses for their cameras.

Tilt And Shift Lenses

These are specialized lenses used for tilt and shift photography. Tilt and shift photography uses camera movement itself to shift focus, usually downward or upward, but sometimes side to side, in order to avoid perspective distortion. This type of photography is most commonly used in landscape and architectural photography. It's useful in any photography, though, where the plane of focus needs to be changed. These lenses can be used to shift the depth of field without changing the aperture, through controlling the plane of focus.

The same lenses can be used to create a "faux miniaturization" effect, so that the objects photographed appear to be miniature. These are quite expensive lenses, though, and probably not worth the cost unless needed professionally.

Things to Know Before Buying

As noted, these are very pricy lenses. To get a good one that fits your camera, you're likely to spend at least in the neighborhood of $500, and possibly closer to a thousand dollars even at the lower end (depending on the manufacturer). If you need a tilt and shift lens, you're certainly doing some specialized photography and it's important to pay attention to the specifications and make sure it will do what you need it to do in terms of mechanics on the tilt mechanism, as well as the usual parameters for lenses like focal length and minimum and maximum aperture.

Recommended Lenses

For the best selection of lenses go to Amazon. In the dropdown menu of the search bar choose "electronics" and hit the search button. On the left sidebar on the next page you'll find a category called "Camera, Photo & Video". One of its sub categories is "Lenses". Click on it and on the next page click on the "Digital Camera Lenses" sub category. There you'll be able to filter your results by brand, minimum/maximum focal length, lens type, maximum aperture rate, price and more.

Filters

A filter is a transparent, but light-altering attachment that goes on the camera lens and produces various effects. A lot of different filters were developed for analog photography, but most of those aren't necessary when using a digital camera. The effects can be produced either by adjusting the camera settings or in post-processing with Photoshop or another graphics program. However, there are several exceptions which are still useful in digital photography, of which the most important is probably the polarizing filter.

When buying filters, one question that arises is whether to buy a shaped round filter that screws into the camera lens itself or a square or oblong filter that has a separate mount. The advantage of the round filter is convenience: all you have to do is mount it on your camera lens and you're

good to go (and of course, just remove it when you want to take pictures without the filter). The disadvantage is that it only fits one lens size, and lenses often have different diameters. The square or oblong filter can fit over any lens, but requires more set-up time and is bulkier and less elegant. However, if you want to use multiple lenses in settings where a filter would be useful, then either you have to use a square or an oblong filter and frame, or else buy multiple round filters, one for each lens size.

Things to Know Before Buying

Photographic filters are easy to find, quite inexpensive, and of consistent quality. Just make sure that the filter is the right size and compatible with your lens and you're good to go.

Polarizing Filter

A polarizing filter removes reflections from an image, creating many different effects that are often useful in certain types of photography, especially outdoors under natural light. It can enhance color, make water appear more transparent by removing the reflections from its surface, and remove the glare from the sky or from brightly reflecting surfaces when shooting outdoors in daylight. Unlike a lot of other filters, a polarizing filter allows for different effects depending on how it's positioned in the shot. The filter can be rotated after attaching it to the lens, and you can see the different quality of the picture depending on the filter's position. With a single-lens reflex camera (whether digital or analog), just look through the viewfinder and adjust the filter to see what the effect will be on your image.

A polarizing filter is especially useful in shooting through or around bodies of water such as on the seashore or around lakes, rivers, or ponds. The glare from reflected sunlight off water can ruin a picture, making it appear washed out and dimming the power of the colors. A polarizing filter can eliminate this glare and also allow photographing through the water to objects on the bottom. (It can also be useful in underwater photography, but of course special equipment is required for that to protect the camera from the water.)

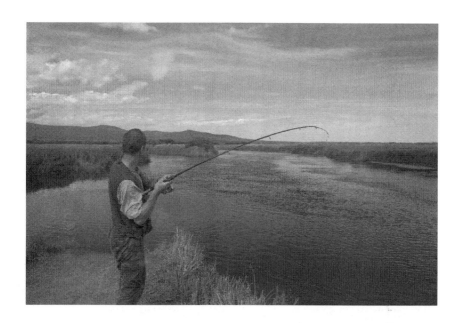

A polarizing filter also changes the color and appearance of the sky. It can remove the smoggy haze that prevails in urban settings and can also make the sky appear a deep, vibrant blue rather than a pale blue. This effect depends on the position of the sun, though.

Finally, a polarizing filter can remove reflections even where you think there aren't any. An object doesn't have to have a "mirror finish" for reflection to distort its color in a photograph. With a polarizing filter, colors are often brighter and more distinct than without. Is this effect good or bad? As with most everything else in photography, it depends on what you're shooting for, but having the option is definitely a good thing.

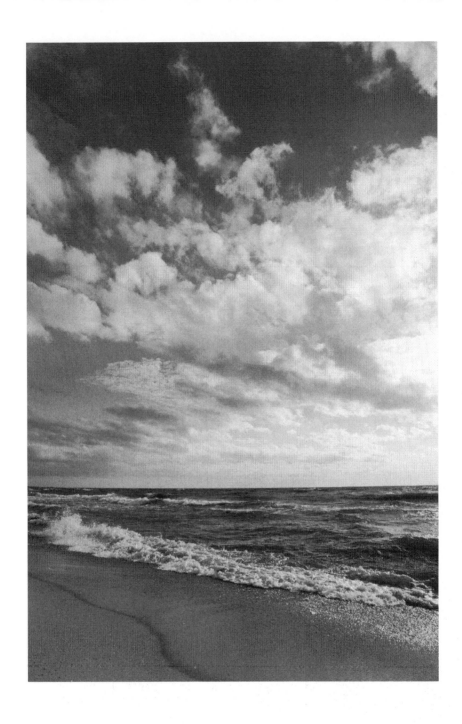

One thing to bear in mind when using a polarizing filter is
that it changes the appropriate settings for exposure. The

filter dims the light going into the lens, which means that you need to use a slightly slower shutter speed or wider aperture than you would normally use for a given shot.

Neutral Density (ND) Filter

A neutral density filter cuts down the light going into the lens at any particular aperture (like what was noted above for a polarizing filter, except with the ND filter that's the whole point). What the ND filter does is to reduce the intensity of light at all wavelengths equally, so that you still get the same color balance but at a reduced light volume. This allows use of slow shutter speeds or wide apertures that, at normal light intensity for the conditions, would result in overexposure. The reason to do this is, of course, for the effects that slow shutter speeds or wider apertures provide. A photographer might, for instance, want to shoot a photo of a waterfall at a slow shutter speed that results in a blurred, motion-suggesting effect. In outdoor, daylight conditions, using such a slow shutter speed would be overexposing the picture, but by using an ND filter, it's possible to take that shot without overexposure and get the effect desired. Another example is taking close up shots of flowers in a garden, with the remainder of the picture blurred. This effect is achieved with a wide aperture and consequent low depth of field, but again, a wide aperture might result in overexposure. Using the ND filter prevents that.

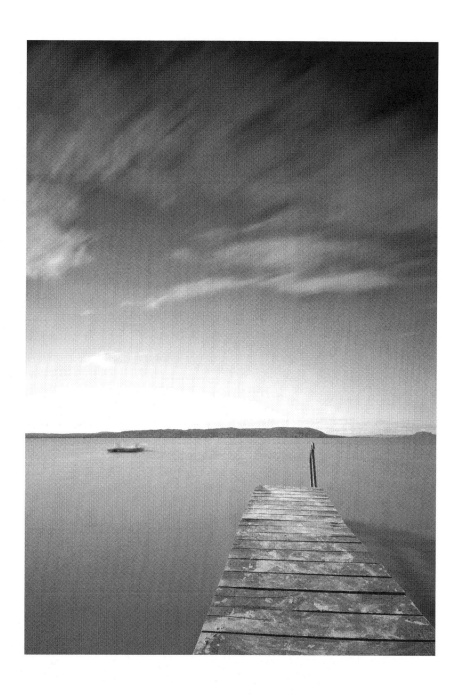

A variation on the ND filter is the graduated ND filter, in which part of the filter is neutral density and the other part is clear, with a graduated transition between the two. This

allows the photographer to dim the light from part of the picture while leaving the rest of it in normal condition. For example, when taking a photo outdoors under a bright sky, using a graduated ND filter can dim the sky while leaving the rest of the picture normal. There are many different types of graduated filter depending on where the dimming effect occurs in the field of vision. Sometimes the filter has a clear section in the center and dimming on the periphery, while other graduated ND filters draw the dividing line horizontally so the upper portion is dimmed while the lower portion is not. Each of these filters would be suitable for taking a different composition of photograph.

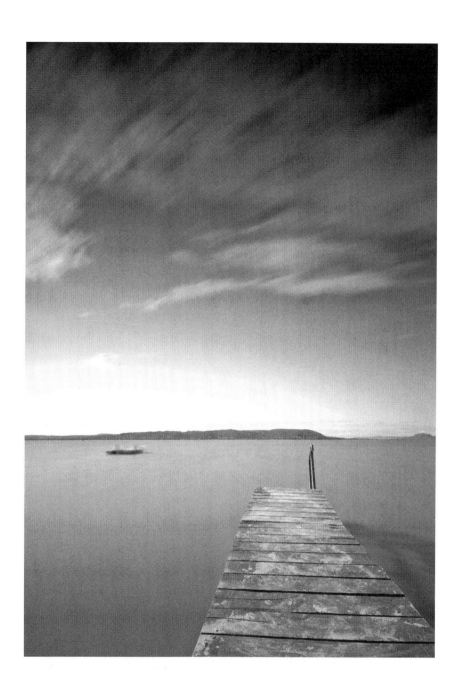

A variation on the ND filter is the graduated ND filter, in which part of the filter is neutral density and the other part is clear, with a graduated transition between the two. This

71

allows the photographer to dim the light from part of the picture while leaving the rest of it in normal condition. For example, when taking a photo outdoors under a bright sky, using a graduated ND filter can dim the sky while leaving the rest of the picture normal. There are many different types of graduated filter depending on where the dimming effect occurs in the field of vision. Sometimes the filter has a clear section in the center and dimming on the periphery, while other graduated ND filters draw the dividing line horizontally so the upper portion is dimmed while the lower portion is not. Each of these filters would be suitable for taking a different composition of photograph.

Ultraviolet Filter

An ultraviolet filter is a filter that blocks ultraviolet (UV) light, which is light that is higher in frequency (lower in wavelength) than visible light. Ultraviolet light is a natural part of sunlight and is the cause of sunburns and tanning. We cannot see ultraviolet light with our eyes, but often camera film in analog photography picks up some of it, resulting in a distorted image. By blocking out UV light, the ultraviolet filter restores a true-to-vision image.

In digital photography, the ultraviolet filter isn't needed for its optical effects. Why use one, then? For lens protection! Since the ultraviolet filter is transparent to visible light, and blocks only UV light, it does not distort pictures at all, but can be left on the lens in just about any situation where you don't need a different filter. It protects the lens against grit and damage, and is easily detached and cleaned, compared to the lens itself.

Composing the Picture: Light, Framing, Focus

The great thing about a single-lens reflex camera (whether digital or analog) is that it allows you so many options in regard to composing your picture! Your camera can, with a change of only a lens, become a telephoto camera, a close-up camera, a portrait camera, a sports camera, a wildlife camera, or almost any other kind of camera. But with that versatility come factors that must be kept in mind.

Photographic composition is the term used for changing what is in the picture and how it is taken so as to create the effect and image that you want. This is a far cry from pointing and shooting a snapshot! You may in many cases compose your picture by changing what is included in it. This can be done most easily with portrait photography or studio photography. You can change the backdrop, the clothing and hairstyles worn by your models, the poses, and all the other features of the picture so that what you are looking at changes, and so of course will the picture you take of it.

When photographing something in nature or otherwise out in the world, your opportunities to do this sort of thing are much more limited. But that doesn't mean you can't artfully compose the photo! It simply means that you must use different methods. Instead of changing what you are shooting at, you change how the shot is taken so as to capture different parts of it, from different angles, and in different ways, so as to create different images.

There are three main factors that are involved in photographic composition, other than controlling the subject matter. These are lighting, framing, and focus.

Lighting

In studio photography, just as you can control the subject matter, so you can control the intensity of the lighting by changing the lighting itself. In outdoor photography that isn't possible, but you can still use lighting to help compose your photos.

One way to do this is to select the time of day or weather conditions under which you take the photos. You will achieve a dimmer, more diffuse light on an overcast day than you will under bright sunshine. Also, different

lighting conditions prevail at night, under artificial light (or moonlight) than in daylight.

The other way to control lighting outdoors is to start from the other end. By adjusting the aperture, shutter speed, and ISO sensitivity of your camera, you can increase or reduce the amount of light entering the camera and so make the picture brighter or dimmer. This can be used to overexpose or underexpose the photo deliberately. Overexposing the photo gives it a more "washed out" appearance, bringing up detail in things that are in shadow that might not be shown in a "correctly" exposed picture. Deliberately underexposing it on the other hand deepens the colors and shades in brighter parts of the picture, at the cost of making the dimmer parts even less visible.

Photo of a highway at night using long exposure time.

Besides deliberate over- or under-exposure, you can use your control of the three factors behind exposure (ISO sensitivity, shutter speed, and aperture) to take pictures in very dim light that appear as if they were taken in somewhat brighter light. This can allow nighttime photography without the use of flashbulbs or electronic flash.

As you take more pictures, you'll get a better feel for what your camera can do in terms of exposure and what changing each of the exposure-relevant variables accomplishes. Remember these three rules of thumb:

1) A wide aperture lets in more light, but reduces depth of field.
2) A slow shutter speed lets in more light, but increases blurring due to motion of either the subject or the camera.
3) A high ISO sensitivity increases the apparent brightness of a picture, but at very high levels also increases graininess.

Keeping these rules in mind will let you adjust light sensitivity in the way that will produce the effects you want.

Here are some other rules of thumb that will help you in controlling the lighting conditions either outdoors or in the studio.

The broader the light source, the softer will be the light. Conversely, with a narrow light source, you get a crisp, sharp light. A broad light source softens shadows and contrasts and lowers textures. That's because a broad light source allows light to hit the subject from multiple directions. In portrait photography, for example, a soft effect can be achieved by positioning the subject near a large window that does not have direct sunlight exposure.

The more distant the light source, the harder the light. This is actually a variation on the above rule. If you position a light source closer to the subject, it will be larger relative to the size of the subject. If it's shining from a distance, it's more a single-direction light source that sharpens contrasts and shadows. You can use this rule to create the most flattering images (or the most creative and desirable ones) in indoor photography.

Diffusion scatters light and makes for softer lighting. Diffusion refers to light shining through a translucent substance, such as clouds, fog, or filters and screens. A picture taken outdoors on an overcast day or in a fog will be softer in effect than one taken on a sunny day. The same principle can be used indoors through the use of filters and screens to create a diffused light and produce a softening effect. You can make your own filters using materials such as white cloth or translucent plastic. Outdoors, you can use a

light tent or canopy to diffuse the sunlight in the absence of any natural clouds or fog.

Bouncing light diffuses it. If you shine your light source not directly on the subject but rather on a matte surface such as a white wall or a matte reflector, a softer quality of light will be produced.

Note that this really only works with a matte reflector. If you use a shiny reflector, such as a mirror or a piece of polished metal (something you can see your reflection in), the light will remain almost as sharp as if it were used directly.

The more distant the light source, the more it weakens. This is a pretty obvious one. A light source is stronger and brighter when it's closer to the subject of your photograph, and weaker and dimmer when it's further away. There's a mathematical principle called the "inverse square law" that governs this, which says that light varies inversely as the square of the distance from the source. That means when the source of light is twice as far away, it's four times weaker. When it's three times as far away, it's none times weaker. Just remember that when a light source is farther away, it becomes sharper, but also weaker, and adjust your expectations accordingly.

The closer the light source is to the subject, the sharper will be the falloff of light on objects in the picture further away from the light than the subject. When you shine a light from a short distance on something in the foreground, the light is much

dimmer (in proportion) on anything a bit further away from the light than the subject is. For example, if you photograph a person with a bright light shining on his face from a short distance, the light on anything behind him (due to the inverse square law) will be dimmer. Because you set your shutter speed and/or aperture based on the light on the subject, the other objects in the picture can appear to be dimly lit. If the light is further away, the difference between the lighting on the foreground and background will be less, and the whole picture will seem more evenly lit. You can use this tip to control how much background shows up in the picture.

Lighting from the front softens texture. Light from the side, above, or below sharpens it. If the light is coming straight on from the front, the details and textures in the picture will be softened. This is often a good thing for portrait photography as it can soften imperfections. If you want the textures of your subject sharply defined in the picture, arrange it so the light comes in from the side or from above or below. (Of course, each of these will also make a difference in terms of shadows cast and other variations.)

Shadows generate a sense of volume. When shadows are sharply defined, they create a three-dimensional feel to the photograph (which is, of course, a two-dimensional image). Several of the lighting tips above can be used to deepen shadows when a three-dimensional feel and sense of volume are desired. For example, using side lighting or angular lighting can deepen shadows and thus create volume.

Backlighting creates highly diffuse lighting, but makes for difficult light metering. When most of the light source is from the back, the reflected light off a surface in front of the subject (such as a wall) can provide very soft, diffuse lighting. If the light source itself is in the photo, this can create some very interesting effects such as silhouettes, but you have to be careful when using your light meter. This creates what's called a "high dynamic range" (HDR) lighting situation and requires a technique called "exposure bracketing." Exposure bracketing involves taking three different shots, one exposed exactly as the meter says, one about one-third underexposed, and the last about one-third overexposed, to compensate for errors that may arise when sampling in high-variable light fields.

Even light your eye sees as white has color to it. The color of apparently white light is called color temperature. Our eyes and brain adjust our natural perception so that we don't notice this variation much, but a camera does not. That's one reason why the image taken by your camera may not perfectly match what you see with your eyes. Sunlight in the early morning and late afternoon, not long after sunrise or before sunset, can generate a warm-color cast to the picture. Bright noonday sun, on the other hand, gives the photo a bluish, cool-color tone. Your digital camera has a white-balance control that lets you shift this color balance either to compensate and neutralize the color temperature or to emphasize it for deliberate effect. One use of this feature involves landscape photography. On a clear, bright day, a landscape photo can be strongly blue-shifted in

appearance. If you set your camera's color balance to "cloudy," you can compensate for this and give your photo a warm glow.

Framing

The "framing" of a photo refers to what is included and not included in your picture, from among all the things that your eyes see.

In the studio, obviously, you have more control over what goes into the picture than you do with outdoor photography. However, you can still exercise a lot of control when shooting photos outside of a studio. Here are some of the questions to ask yourself as you prepare to take a picture.

1) What should be in the center of the photo – the object or space where the camera should be pointed?

2) What should be at the edge of the photo? Many times, it's possible to set things up so that some natural object creates a "frame" around the picture. (This is where the term "framing" comes from, in fact.) For example, if you're shooting an outdoor picture, the trunk and one horizontal limb of a tree can create a border. A wall, the edge of a street, or anything else that can draw a line at the top, bottom, or edge of the picture can serve the same purpose. Aside from this, attention to what appears at the edge is part of composition of the picture; you want it to direct attention to the center rather than distracting.

3) Decide how much else should be in the picture. Ideally, every element that appears in the shot should add to the whole and not consist of meaningless clutter. You can control a lot of this by

changing your position before taking the shot, or by using a zoom lens and carefully positioning the frame.

4) Choose your angle carefully so as to make everything the right size, positional relationship to other elements of the photo, and importance in the picture. The mark of a truly great photo is that your eyes are immediately drawn to exactly what the photographer means to be the center of attention, and move according to a plan.

Example of framing using buildings and street edge.

Rule of Thirds

The "rule of thirds" is a technique or rule (although there is no such thing in photography as a hard and fast "rule") about how to compose a picture using the elements in it. Divide the picture into nine parts of equal size using two vertical and two horizontal lines. The four interior intersections of these lines are the main points of interests in the photo, where the eyes are naturally drawn. The photo should be composed with the understanding that these points in the middle of the picture are where people will look first. Usually that means the main items of interest should be located at or near one of those points, but sometimes an interesting photo can be constructed by having something at those points that draws the attention to another part of the photo where the main subject resides.

[caption: Positioning of the dog in this picture employs the Rule of Thirds]

Including Context

Context arises when you think about the theme of your photo. What are you trying to portray? What is the main subject? Context is anything that relates to that, which can logically be included in the picture.

For example, using tree branches, an archway, a doorway, or a window to frame a picture each conveys a different impression about the setting, which may related to different themes, ideas, and main subjects. Including other objects besides your main subject can also add context (of course this is easier to do in an arranged photo such as in a studio).

For example, if the subject is a musician, context could include a musical instrument; if a scientist, a lab coat and laboratory equipment, or a blackboard with equations

could provide context; if your subject is a woman about to go out on the town, her clothing and surroundings can be chosen to reflect this theme.

Be aware of all the details that will appear in the photo and make sure they all fit together, and that each is correctly emphasized.

Layers and Depth

Another use of framing is to add depth to the photo or layers of subject. Your main subject will be further away than the frame in most cases (although not all – but if the frame is further away than the subject, that also adds layers and depth). The feel of looking at the subject through the frame gives the photo a three-dimensional feel.

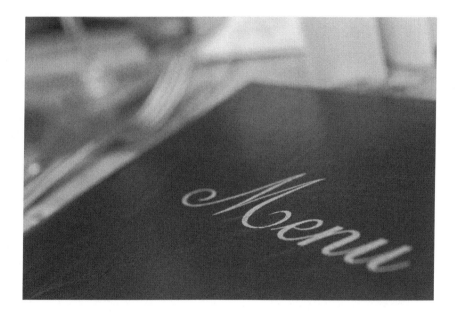

Focal Points

The framing of the photo should draw attention to the intended focal points. There is always at least one focal point intended to a photo, and sometimes more than one. When your eye falls on something other than the focal point of the picture, it should be led to the focal point. Ideally, a photo should be constructed so that the eye makes a journey through it to touch upon each intended subject in sequence as if following a trail. This can be done through careful use of lines, shades, and objects that are near to or lead the eye towards other objects. It's hard to present a formula for doing this, but you can test it in each case by looking at the composition and seeing where your eyes travel.

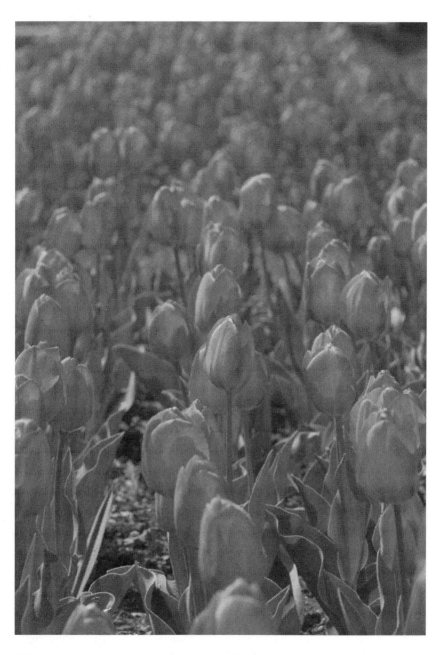

Photo taken using multiple focal points.

Integrity and Wholeness

Try not to shave off part of anything that is a main subject of your photo, or anything that might draw people's attention. That's especially the case when the object is in large part depicted in the photo. You want to avoid cutting off a small part of it. If the eyes are drawn to the object, having a part of it disappear from view can draw attention to the missing part, in a way that is jarring and unpleasant or gives a sense that something is wrong or incomplete.

It's acceptable, on the other hand, to have a *large* part of the object be out of view, so that what *is* in view only gives a suggestion of the object. This is often done in framing, with the frame presenting only part of an object (such as a tree, building, or roadway), the rest of which is out of view.

Lines, Colors, Textures and Shapes

Every photo is composed of four things: lines, colors, textures, and shapes. Lines appear naturally at the edges of things and can be straight or curved. Colors include shading and brightness and can excite or soothe, call attention or divert it. Textures can be intensified or softened through use of lighting and can also be emphasized or de-emphasized by placement within the photo (a texture that is in shadow or under soft lighting will show up less than if the textured object is moved so that it appears in bright light).

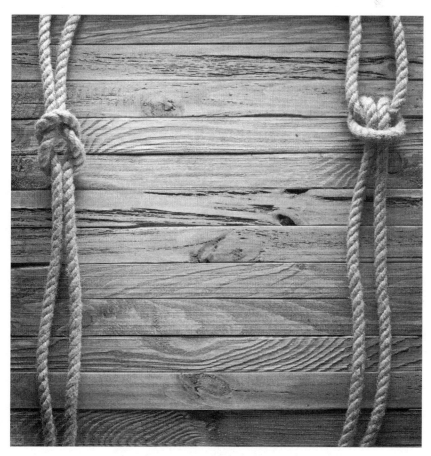

You can use these features of the photo to create attention paths. The eyes naturally track along lines, while they naturally focus on recognized shapes. Colors shape the mood of the person seeing them, and textures give a feel to the photo. All of these are elements of composition that can be used as if one were painting a picture. The techniques differ, but the end result can be very similar.

Simplicity and Empty Space

Sometimes, less is more. A photograph includes everything that the camera takes in, and that can make for a jumbled, cluttered picture. This can be fixed through the use of framing, along with lighting and focus, to simplify the photo. You can adjust the perspective and what is included in the photo so that only the things you need to have in the picture are in it.

Don't be afraid to have empty space be part of the picture! A photo that includes a few, or even just one object of attention can be very powerful. The ratio of empty space to objects of attention should be no more than about three to one, but that is acceptable; the entire picture doesn't need to be filled up.

One rule about empty space to keep in mind is that a moving object should have more empty space in front of it than behind it. If there is not much space shown in front of the moving object, it gives the impression that it's going to crash. (Like all rules in photography, however, this one has exceptions. It can be useful to make the picture look as if the moving object is going to crash – into the viewer, for example, or to create that effect for a different reason. Always be aware that that is what you are doing, though.)

Eye Contact

When you are photographing a main subject that has eyes (a person or animal), most of the time you will want to obtain eye contact. Even if the picture you are taking is one where the subject is looking away from the camera, making eye contact first so as to put your focus on the same level as the subject's eyes, and then having the subject look away to take the actual photo, is a good technique. It creates a greater level of identification between the viewer and the subject by putting the subject on the viewer's eye level (as the position is perceived when viewing the photo).

There are exceptions to this rule as well. These exceptions come when the subject with eyes is not the main focus of the photo, for example when a person or animal is in the

picture to give size perspective to something else that is the main focus of attention. It's a good idea to learn how to follow the rules first before learning how to break them, though, and this one is no exception.

Focus

The third way in which framing may be accomplished is through focus. This consists of three things:

1) What the center of focus is for the photograph.
2) How sharply in focus that center is.
3) How sharply in focus the rest of the photograph is.

In almost all cases, the center of the photograph should be sharply in focus. However, there *are* exceptions. (As noted repeatedly above, there are exceptions to almost every rule in photography just as in any other art.)

Controlling the focusing (once you've focused on the main subject appropriately) is mostly a matter of controlling the depth of field by setting the aperture, and controlling the motion blurring effects by setting shutter speed, although much can be done with the effects of lighting on focus, too. Do you want your photo to be entirely crisp, clear, and in focus for all of its elements? Do you want part of it to be sharp and clear and the rest somewhat blurred, so as to direct attention more powerfully to the center? Do you want to convey speed or movement with a streaked or blurred effect of a moving object such as a leaping animal, a race car, or an airplane? Or do you want instead to capture all of the visible details of the object with perfect clarity?

There is no always right answer to any of these questions! That's what makes photography an art form. Although general tips can be given in a book like this, in the end the only way to learn it is to do it. That's how you'll discover

what happens when you set your aperture to f4 while leaving the shutter speed automatic, or set your ISO sensitivity to 1600 and leave everything else automatic – or any of the huge number of other possibilities.

Point of Focus

The term "point of focus" means the object within a photographic composition to which the photographer means to draw the main attention. For purposes of setting focus, almost always the point of focus should be in sharp focus and definition. The remainder of the photograph raises questions about sharp versus blurry focus. (As always, there are exceptions, but in this case they are rare.)

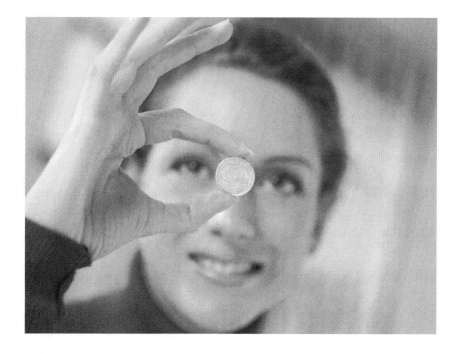

A DSLR camera often allows for setting the point of focus manually, so that it does not always have to be in the center of the frame. Many of the better and more advanced DSLR models even allow for setting multiple focal points. When you do this, the camera's automatic focusing control takes

samples from each of the focal points and processes an overall focus that will try to keep all of the focal points in sharp focus, as much as is possible given the depth of field that arises from the aperture setting. One should always use this control with discretion and artistry and not go hog-wild. Using too many focal points leaves the viewer's eye with no place to rest and no strong point for attention. It can make a photograph seem overly busy.

Another important thing to keep in mind is the relation between focal point and photo composition. If the foreground is cluttered with out of focus objects while the focal point is behind them, this can be distracting unless it is very carefully handled.

The traditional focal point in the center of the frame should be the default in your mind. DSLR camera controls allow you to depart from this traditional composition, opening up extra possibilities. That's a good thing, but it should be used judiciously and with a certain amount of caution until you feel confident about the technique.

Using All the Camera's Focal Points

Despite what was said above, there are some circumstances when it is advantageous to use a lot of focal points, or even *all* of the focal points the camera offers. This would be when you are taking photos of moving objects whose motion is unpredictable, such as often occurs with sports photography or wildlife photography. It can be very difficult to keep a fast-moving creature such as a bird or a football team in a pre-defined focal point (such as the center of the frame). Using all of the focal points in such a case improves the ability to keep the object in focus by having the camera's computer chip take care of the job for you.

Depth of Field

Controlling depth of field is a matter of using aperture settings (mostly) and lighting (to a lesser extent). We've discussed this subject above, but here are a few more tips and thoughts.

When you want to bring a single subject to the foreground as the focal point, a shallower depth of field is the best approach. Having your subject be sharply defined while the rest of the photograph remains blurry and out of focus can bring more attention to your subject and avoid distractions. Portrait photographers do this a lot. However, there are some cautions that should be kept in mind.

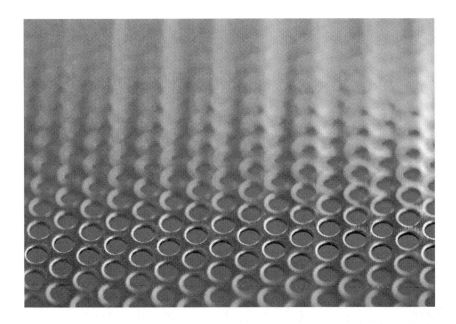

One cautionary note involves avoiding a cluttered but blurry photo. If your background is busy but out of focus, this can actually detract from your subject by drawing attention to blurred objects that are hard to recognize. The mind wants to ask, "What the heck is that thing?" rather than simply letting the background be background. With shallow depth of field, you want the objects in the background to phase into one another so that none of them draws attention in particular but all of them serve to frame the main subject. With a busy background, if there's no way to compose the picture so as to reduce the busy aspect of it, the best approach is often to use a wide depth of field so that all of the objects are in focus. Use another method, such as framing, to draw attention to the main subject.

Focus Modes

A DSLR camera has (usually) three different modes of focusing which are set with a control. These are AI servo focusing, one-shot focusing, and manual focusing.

One-shot focusing allows you to use one control in one position (usually depressing the shutter button partway) to automatically focus on the focal point (by default the center of the frame, but this can be reset to some other location), after which the picture is taken and the focus is lost. You have to do the same process again to focus on a different focal point (or on the same one). This is the way auto-focus used to work on all cameras prior to the digital revolution, and it's still the most common, popular, and easy to use method.

AI servo focusing allows you to hold down the shutter control and take pictures in rapid succession, click, click, click. The camera focuses automatically on the focal point (again, by default and normally the center of the frame) before each picture is taken. This allows you to take multiple shots of a moving target far more easily than you would be able to do with one-shot focusing.

Finally, manual focusing is just that. You turn the camera's AI off and use the Force – that is to say, you set the focus manually by looking through the view port and seeing whether it looks like it's in focus or not. This is a good idea when doing macro photography, because the tolerances for focus are quite small, and the autofocus is more likely to make small errors that translate into a blurred subject when taking close-ups. It's also a good technique for shooting landscape pictures at night, when the autofocus finds it difficult to lock onto the target.

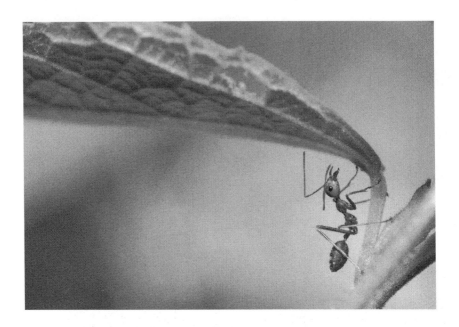

Most DSLR newer cameras allow you to combine autofocus and manual, letting you fine-tune the focus after the autofocus has locked in. As long as you have the time to use it, this is often the best of both worlds.

Panning

A panned photograph is one in which the camera is moved along with the subject, especially with a slow shutter speed. The moving object in the foreground is in focus, while the background is blurred, not because of a shallow depth of field but because of motion blurring (the motion in this case being that of the camera rather than that of the objects. This can create an interesting effect.

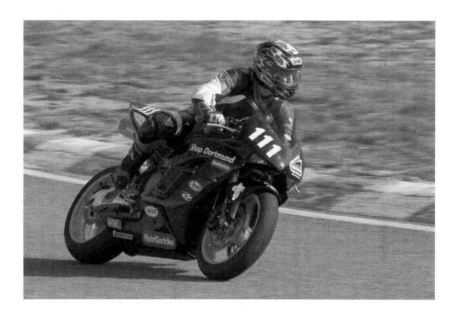

It's probably easiest to use the AI servo autofocus technique to take a panned shot, as this will allow multiple pictures to be taken rapidly and likely some of those will come out well. Alternatively, you can pre-focus the camera on a point before the moving subject gets there, follow the subject as it moves, and take the shot when it arrives at that

location. Of course, this latter method requires that the motion of the subject be predictable.

Lens Effects on Depth of Field

The type of lens you are using has a big effect on depth of field. For example, it's difficult to achieve much shallow depth of field effect when using a wide angle lens, even with a fairly wide aperture. Telephoto lenses, in contrast, make depth of field shallower with any given aperture width.

There are some techniques that can modify these effects, such as moving the physical distance between the camera and the subject so as to change the focusing parameters. However, the best technique is to know your lenses well through practice and familiarity, and know what you need to do in order to take the picture you want with any given lens.

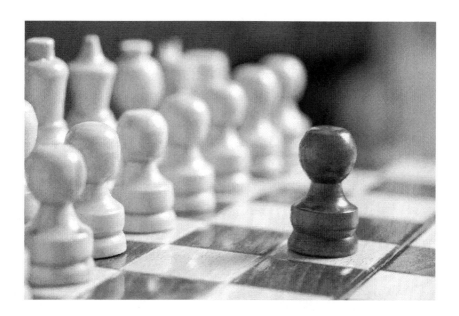

Downloading and Storing Your Photos

Once you've taken a photo with a digital camera, it goes into the camera's internal memory. From there, it will be necessary to transfer the photos to a computer or other processing device before much can be done with them. (That may change in the not-too-distant future, as data processing functions continue to be integrated. For now, though, it holds true.) The technical procedure for doing this will vary from camera to camera. More importantly, here are some rules to go by when you move your photos around.

1) Always make sure there are two copies (or more) of any photo in existence at any one time.

2) One of those copies should be stored at a remote location so that it will survive the destruction of your hard drive if that should happen. Cloud storage is great for this.

3) When you work on photos using a graphic arts program, always save your worked-on copy to a different file than the original. In fact, before you start to work on it, make a copy of the original photo in the *same* format. Then pull one of the two into your graphics program and work on that, making sure the copy you aren't working on is labeled "original" (or the equivalent) and kept in its original condition and format. That way, you'll always be certain you still have the original as it originally was.

4) When you publish a photo, whether in its original form or as modified, include a copyright statement to establish your intellectual property rights. (It isn't necessary to register your work with the government. It's copyrighted if you have the rights to it in the first place and you say it is.)

All of these procedures are intended to keep your hard work from getting lost or stolen. The great thing about digital photography is that it's so much easier to do that with a digital file (everything but the stolen part anyway) than it is to make sure nothing happens to a negative – especially since bad things *will* happen to negatives purely through the passage of time. That isn't the case, happily, with digital records. The equipment on which digital photos are stored can wear out, but the records themselves can't.

Here are the main formats that digital photos can be saved to. Your camera will only be able to handle a few of these, perhaps only one of them, but any good graphics program should be able to convert the files and save your photos in multiple formats. Computer processing has taken the place of the art of photo development that, in the days when analog photography dominated, was a crucial part of the photographer's art.

A word about photo compression: this is a technique (actually several techniques) for reducing the file size of digital photos so that they take up less memory space. Compression is generally divided into two categories,

lossless and lossy. Lossless compression uses algorithms that perfectly represent the information in the digital photo so that none of that information is lost. Lossy compression discards some of the information but in a way that the eye usually can't see; it preserves what the developers believed to be the "important" parts of the information.

Here are some of the common formats for saving digital files, not including the ones that are proprietary with particular graphics programs.

RAW – this is any of several file formats in which your camera can compress files for computer storage. It is a lossless compression method and usually a very good way to store information, but the bad part is that it is different for each camera manufacturer, so you may not be able to use a RAW file with much besides the camera itself or viewers produced by the manufacturer.

TIFF – a versatile storage medium that is usually lossless and takes up a lot of memory space but preserves very high quality. In many cases, TIFF files use no compression at all. Most graphics programs will read TIFF files and often that is the default way that they save graphics files. However, TIFF isn't as useful as some others for purposes of publication and transmission, simply because the files are too big to make that quick and practical.

PNG – this is another lossless compression method that, unlike TIFF, does usually compress the files, although not as much as lossy compression methods do. It's a good way

to store files in an "intermediate" stage, because it preserves more information than a JPG file, even though it's not as convenient for immediate publication.

GIF – this is a normally lossy compression method that creates a pool of 256 colors and renders the picture, if possible, into those 256 colors. If the picture has more colors than this, some of its information will be lost in the compression.

JPG – this is a lossy compression method that is designed and optimized for color photos, so that these compressed files preserve an enormous amount of the information from the photos. JPG has become the standard for most image files published online. All graphics programs will save to JPG format, and the better ones will all allow you to adjust the amount of compression, balancing file size against quality of image.

For the most part, you'll find yourself working with JPG and PNG files. It's a good idea to save two original copies uncompressed, though, and copy these into compressed formats as needed. In almost all cases where you are publishing photos online or transmitting them by email, JPG files will be quite sufficient to preserve the image faithfully at the same time as the format allows a highly compressed file size for quick transmission and low-volume storage.

Using Graphic Design Software

Taking the picture – although there is a tremendous amount of art to that – is only the first step. Once the photo is taken and you're satisfied with the image as it appears on your camera's screen, and once you've downloaded it to your computer hard drive and saved a backup copy in a remote location such as cloud storage, you will want to do something with it. At minimum, you'll probably want to save it to a different file format to make it easier to publish the photo or share it with other people over the Internet. The bigger the file size, the longer it will take to transmit. Compressing the file allows it to be moved online more quickly, and for that if nothing else you require a decent graphics program.

A grasp of computer graphics also allows you to modify the photo in a lot of different ways, including:

1) Editing and improving the photo itself. Using a graphics program, you can eliminate cluttering details, sharpen colors and contrasts, dampen distracting reflections, and make other changes to the photo that improve on what you were able to achieve with the camera. Don't think of this as "cheating," unless of course you were taking the picture as some sort of legal evidence (and in that case you're engaged in forensics, not art). Think of it as making your photos the best they can possibly be. In analog days, while the possibilities were a lot more limited, photographers could still use techniques such as cropping and variation of

development technique to change the way a photograph looked. It has always been possible to do this to some degree on the back end (as it were).

2) Incorporate the photo into various graphic designs. This can range from a Christmas card to a book cover design to a letterhead to a banner for a web site to – well, anything, really, that can be published or shared. You can add other images or text to the photo, provide a frame around it, crop part of it and splice it with other images to create an interesting mélange, or even use multiple photos in a moving collage. The sky is the limit!

3) Save either the photo itself or the creations outlined above in other formats for easy transmission and storage.

Not all graphics programs are created equal. Some have more capabilities than others, while some are more user-friendly than others. A complete and exhaustive description of graphics programs and what you can do with them is beyond the scope of this book, but here are several of the better graphics programs on the market and their good and bad points.

Adobe Photoshop. This program is one surely everyone's heard of by now, and for good reason. It's fairly pricey ($700 or more depending on the package), but for the power of the tools combined with ease of use, there's nothing else on the market quite like it. It's professional grade and quality, and can produce professional quality graphic art, but it's simple and user-friendly enough that

someone who isn't a professional can use it well. If you already have Photoshop, there's not much reason to look at any other program.

Corel PaintShop Pro. Corel is famous for its full-featured graphic arts software, CorelDraw. Easily as powerful as Photoshop, and the professional standard for years, CorelDraw isn't quite as user-friendly, and only a bit less expensive. There's a steep learning curve in the beginning. However, there's a wealth of training materials that can make the process easier. Again, the price tag isn't for the faint-hearted (about $500 for the full graphics suite), but given the capabilities of the program and the availability of superior customer service from the company, it may well be worth it.

Those two, Adobe Photoshop and CorelDraw, are the most popular professional-grade programs on the market. There's one open-source graphics program that can be downloaded free that has many of the same capabilities, but is more difficult to learn. It's called GNU Image Manipulation Program, or GIMP. (The acronym is in universal use.) GIMP is not quite as full-featured as Photoshop, but it has all of the main features and it's free. You can, at worst, manage quite well with GIMP until such time as your artistic ambition takes you in to areas where it won't suffice, when you may decide that paying for Photoshop or CorelDraw would be a good investment. Certainly for just about any application of graphic arts to business purposes, and for retouching photos, GIMP will suffice perfectly well.

GIMP isn't very user-friendly and its controls aren't perfectly intuitive. However, there is an extensive user manual available online as well as plenty of on-line help, both official and unofficial – including some very good videos on YouTube.

These are only a few of the graphic design programs available, of course. But they are the top two programs that require payment and the very best that's free when it comes to working in photography. Other graphics programs may have more to offer when it comes to creating original drawings or electronic paintings, more in the way of 3D capacity, or other features that these three don't offer. But from a photographer's perspective or that of someone who wants to use them along with photography to create things for publication online, these are probably the best programs available.

If you're not already familiar with graphic arts programs, this will be something else that you need to learn which you don't think of as "photography" necessarily. But so it goes in the digital age. With analog photography, you needed (if you were to have any control over this aspect of the art) to learn about how to set up a darkroom, and invest in chemicals, an enlarger, safelights, and all the other equipment necessary for processing your photos from exposed film to finished prints or slides. The use of graphics software is the replacement for all that in the digital age, and it's easier to learn, less expensive, less potentially dangerous (photographic chemicals are quite toxic and potentially a health hazard), and less likely to

result in a disaster that destroys your work. Computer graphics are also more versatile, more fun to work with and a lot less messy and smelly. (If you've ever worked in a darkroom, the smell of stop bath – like concentrated super-powered vinegar – is unforgettable.)

If you want to engage in serious, artistic photography (and it's hard to see why you'd need a digital SLR camera for anything less than that), at least a basic understanding of and skill with graphic arts software is every bit as important as a proficiency with the camera itself. Today, when you're finished taking the picture, you're only half done.

Recommended Software

The three software programs listed above, Adobe Photoshop, CorelDraw, and GIMP, are all recommended. The programs are also available on disc for more conventional installation.

DSLR Video Photography

So far, we've been talking about still photography, and that's a huge and varied subject in itself. But digital single-lens reflex video photography also exists and many of the principles are the same. The camera uses the single lens reflex function so that you are looking right through the lens as you shoot, just as with an ordinary DSLR still camera. Many of the settings are the same as well. The difference is that some DSLR cameras, known as high definition single lens reflex cameras (HDSLR), or digital single lens reflex video shooters, are capable of recording high-definition video. HDSLR is quickly becoming the standard for independent filmmakers, as the quality of image is far higher than with a conventional camcorder. Digital SLR video cameras are a cheaper, smaller, more

convenient substitute for professional-grade video cameras such as are used by television crews for commercial stations, and are ushering in a revolution in video making.

The image quality is much higher, but HDSLRs are also much more difficult to use than older, non-SLR camcorders. There is no simple point and shoot functionality with a digital SLR video shooter, as there can be with a conventional camcorder. Some acquired skill in using the device and some advance planning are necessary in order to achieve the camera's potential. That said, if you are serious about filmmaking and can't afford a professional camera, or don't want to lug the bulky thing about with you, a DSLR video shooter can be a great choice. In fact, the lines are becoming sufficiently blurred that "professional video camera" is a moot term. The film *The Avengers* was shot, in part, using several Canon digital SLR video cameras, due to the small size and convenience for shooting scenes from multiple angles. It's very likely that over the coming years, digital SLR video cameras will replace a lot of full-size camera functions by television producers and big movie studios, as well as being the staple for indie film makers.

The main distinction, other than simply being DSLR, between an HDSLR and a traditional camcorder, concerns sensor size. The sensor is the light-sensing area of the camera, the part that replaces the film in analog photography. That is, it takes the light focused on it by the lens and turns it into a digital image. The sensor size of HDSLR cameras is very large compared to that of a

traditional camcorder. This has important impacts on several different aspects of video photography. Moreover, the sensor size in a digital SLR video camera varies quite a bit. Some cameras have larger sensor sizes than others. A larger sensor means that more will appear in the picture (all else being equal). Without any magnification or wide-angle effect created by the lens, the sensor size determines how wide your picture is and how much appears in it on the edges. At first glance, this would mean that "bigger is better," and in fact a maximum size sensor does allow for the highest quality videos. But there are some trade-offs.

First of all there's the price. The larger the sensor size in a digital SLR video camera, generally speaking, the more expensive it will be.

Secondly, a larger sensor area means you will have fewer lenses available to choose from. There are fewer lenses made to fit the larger sensor area, and using a smaller lens can create several distorting effects such as "lens vignetting," which is an effect where the lens cuts off part of the image. Lenses made for full-size sensor cameras are more expensive than those made for the smaller variety, as well as the cameras themselves being more expensive. The same goes for other accessories designed to work with the larger cameras, and of course the entire arrangement is bulkier and less convenient to use, although still petite and compact compared to "professional" television cameras.

On the plus side, a full-size sensor area allows you to use shallow depth of field more easily. That's because there's

no need to use a light-distorting lens in order to achieve a wide view, and that gives you more options in terms of aperture and potentially soft-focus effects in the background. In fact, the quality of video that can be taken using a full-size sensor HDSLR is generally better than for the smaller versions. The question really comes down to what you intend to do in terms of movie-making. For most purposes, the smaller cameras are just fine and represent a better choice for most shooters, but if you want the highest professional quality, then expect to spend more money and have a longer learning curve.

Sensor size is the most important variable, but there are a lot of other features that vary from camera to camera as well, that aren't of concern when buying a DSLR still camera. These include ISO range, camera image stabilization, available memory or recording length, focus assistance, camera image stabilization, and a lot of other features both mechanical and electronic.

Suffice to say that digital video making is a topic worthy of a book all on its own. What we'll say here is simply that the capability exists, and it's becoming more and more available all the time in higher and higher quality.

Conclusion

We live in a rapidly-evolving world. The technology we have today for all forms of information – including photography – is worlds more advanced than it was fifty years ago. Some things, however, remain the same. When it comes to photography, the best results are still obtained with the standard for photographic art, the single-lens reflex camera. This technology was developed in 1949, decades before the personal computer and digital photography. Even though live LCD preview systems are more "advanced" than single-lens reflex, the versatility of the SLR system with exchangeable lenses and lower shutter lag has still not been matched by anything fully electronic.

There's no reason at all not to meld the best of both worlds. A digital SLR camera that incorporates the true-view fidelity and versatility of the classic single-lens reflex with the convenience and process capacity of digital photography lets you do that. In some ways, this changes the photographer's art, but the changes are mainly in the back end and in peripherals. You don't need to worry about either film types or film developing, but instead you need to learn about file types and digital graphics processing.

The remainder of the photographer's art, and certainly the heart of it, remains what it has always been. It requires a good eye and a feel for what the basic photographic variables will do to a picture. Those variables include shutter speed, aperture, and ISO sensitivity; composition of

the photograph, lighting, framing, and focus; exposure, depth of field, and focal length.

If you're thinking about engaging in photography as an art form, for business, as a profession, or as a serious hobby, I congratulate you on a terrific decision. I hope this little guide will help you do that.

Special Thanks

I would like to give special thanks to all the readers from around the globe who chose to share their kind and encouraging words with me. Knowing even just one person found this book helpful means the world to me, so in return I decided to highlight some of the amazing reviews I received from you so far. Thank you all!

"To say this book is a real value is an understatement. I would have paid double the cost for this book and still been pleased with the information gained...If you are planning on buying a digital SLR camera or giving one as a gift - this book is THE companion guide for no stress, fast understanding and a fast start to taking great photos." -powers

"Black's book is well written, organized, and easy to follow. It is also well laid out, with bullet points to underscore important points and photographs throughout to back up each topic he discusses. I plan to share it with my fifteen year old who is active in his high school photography club. Black clearly loves his profession and is enthusiastic about sharing his knowledge with fledgling photographers. Highly recommend." –J. Rees

"This is a helpful guide for beginners. Although I've been taking photos for 20 years, this book proves to be useful. I found it an excellent read for those just getting started as well as a good refresher for going over the overall functions and modes of the DSLR camera." –Pedroluis

"This book was exactly what I needed and got me up and running very quickly. From shutter speed to lenses and filters, I

feel that a lot is covered here and the fact that the author uses a lot of images in the book for illustration is helpful as well. Great resource!" –TrishFLReader

"This is a very useful book for anyone who has just started using a DSLR camera. This book has everything that you need to help you get the best out of your camera. It tackles all the tricky vocab too so that you don't have to ask an expert and feel embarrassed! Topics covered include shutter speed, aperture, lenses, composing pictures and focus. The book is easy-to-read and to the point. A really handy guide to DSLR Photography that I am sure I will consult again and again!" - RunEatSleepRepeat

"As I am exploring DSLR I will be referring to this book often. I am excited about the results I have been getting so far. I highly recommend it!" -Ally McMahon

"I wish I had invested in DSLR Photography for Beginners, sooner. What I was lacking was a basic understanding of photographic terms. Armed with the information found in this book I have a better understanding of what I am trying to achieve and how to experiment to achieve the look I am going for." – Madeleine Roberg

"I picked up this great guide and am so glad I did! It is very easy to understand, beginning with the basics and walking you through the different components of DSLR Cameras and SLR photography." –Mo Birch

"This is an excellent guide! I am a beginner, and find this very informative and well written. Not too intimidating or hard to understand." –Judy C.

"This is an excellent, easy to understand book for DSLR photography beginners. I took a beginner's course a couple of years ago, and this book contains everything I learned in that course for a lot less money." J. Sherwin

"The author took the time to provide great examples and the visual makes it that much easier. If you need a little help with your photo taking skills this is the book for you! Nice work!:)" – Cathy Wilson

"If you are looking for a book that explains it with simplicity, this will be the one you want to get. I highly recommend it for anyone interested in digital photography." – LifeIsGood